Walker **Evans**

Walker **Evans**

Introduction by
Gilles Mora

 Thames & Hudson PHOTOFILE

*The Photofile series is the original English-language
edition of the Photo Poche collection. It was conceived and
produced by the Centre National de la Photographie, Paris.
Robert Delpire is the creator and managing editor of the series,
in collaboration with Benoît Rivero, assistant director.*

Translated from the French by Ruth Sharman

First published in the United Kingdom in 2007 by
Thames & Hudson Ltd, 181A High Holborn, London WC1V 7QX

www.thamesandhudson.com

First published in 2007 in paperback in the United States of America by
Thames & Hudson Inc., 500 Fifth Avenue, New York, New York 10110

thamesandhudsonusa.com

British Library Cataloguing-in-Publication Data
A catalogue record for this book is available from the British Library

Library of Congress Catalog Card Number 2007900798

ISBN: 978-0-500-41084-4

Printed and bound in Italy

ART/DOCUMENT

When Walker Evans began working as a photographer, in 1928, it was at a time when photography was still very much bound up with art and – despite the efforts of Paul Strand and Alfred Stieglitz to create a language specific to the medium – continued to justify its existence by reference to the other visual arts, in particular painting. Evans was quick to grasp the documentary value of photography, its ability to serve as a mirror for reality: Evans, whose true inspiration came from O'Sullivan, Brady and Atget, regarded every photographic image as essentially a document, a philosophy that led him, throughout his life, to reject the kind of 'artistic effects' which he so disliked in the work of Stieglitz.

Evans's strength lay in accepting and mastering the duality of the photographic document, which constantly swivels between two points, serving both as an imprint of reality that is an inevitable product of the technological process, and as an object of aesthetic contemplation, born of the photographer's artistic impulse. Evans acknowledges this ambiguity in what he himself calls his 'documentary style', which he elaborates as follows: 'The real thing that I'm talking about has purity and a certain severity, rigor, or simplicity, directness, clarity, and it is without artistic pretension in a self-conscious sense of the word.'[1]

This 'real' effect transmitted by Evans's photographic images creates a bias towards a purely documentary reading of his work. And yet Evans's photographs are simultaneously documents and contemplations of the photographic subject and object.

BIOGRAPHY

Born in 1903 in America's Mid West, Walker Evans spent a period in France and Europe in 1926, and other rare intervals abroad, but always remained deeply rooted in the culture and landscape of his birth. He was well educated, a man of culture and something of a socialite, with a passion for women and alcohol, although evidence of his private life emerges only fleetingly from his photographs. What remains ultimately of interest to us is not his personal but his photographic life.

His career can be divided into two periods with, sandwiched between them, what has perhaps prematurely come to be regarded since Evans's death as the key part of his oeuvre, his work for the Farm Security Administration, or FSA, between 1935 and 1938. Prior to this, from 1928 to 1935, he worked as a freelance and from 1945 to 1965 he was the regular photographer for *Fortune* magazine. He then went on to teach photography until his death, in 1975. Evans always made a show of fulfilling commissions, while actually doing exactly what he wanted, being, like many photographers, fiercely and productively egotistical. He never earned a great deal of money – something he appears intermittently to have regretted – although his lack of funds did not prevent him from living the life of the perfect dandy.

Evans was an intellectual, but had the good taste not to show it except through his work. He also had a real appetite for life.

PHOTOGRAPHIC EXPERIMENTS

In 1931, Evans told his friend Lincoln Kirstein that the possibilities of the photographic medium excited him so much that he sometimes thought himself mad.[2]

Throughout his life he was passionate about experimenting with the camera. As early as 1932 he recognized the importance of matching the format (Leica or 8 x 10) to the nature of the project: sometimes, as in Havana (1933) and Alabama (1936), he combined different formats as a means of varying his points of view and his connection with the subject. And he often cut up his negatives – which were storehouses of information rather than set pieces of formal geometry – in an effort to achieve a precise image.

He was particularly radical in his treatment of problems new to photography – for example, attempts to capture images at random (*Subway Photographs*, 1938–41, and *Chicago: a Camera Exploration*, 1946) or to photograph landscapes from a moving train (*From a Train Window*, c. 1950). And it was with the same enthusiasm and imaginative energy that he began experimenting with colour photography using the Polaroid SX 70 at the end of his life.

WOMEN

Evans's work is full of images of women, beginning with the first photographs taken in New York in 1928: women as fetishes (Havana prostitutes, 1933) and women as objects of repulsion (the series of high-street shoppers, taken in Chicago in 1946, expressing what Evans described as a satire of the woman shopper at her worst[3]) and as objects of pity (farm women in Alabama in 1936). In the posters, advertisements and magazine covers that he photographed, Woman, and the ambiguous longing she inspires, is portrayed as a chaotic force, the only truly disturbing – and saving force at the heart of an over-regulated, sanitized society and its system of morals.

FORTUNE

It is easy to forget that a fifth of Walker Evans's images were taken between 1945 and 1965, while he was working for *Fortune* magazine as their regular (and only full-time) photographer. Evans produced a series of portfolios based on themes of his own choice, with an artistic rather than purely informational bias, and which he oversaw to publication, writing the accompanying texts himself. *Fortune* helped to promote Evans's various projects, allowing him the opportunity to experiment widely (as in the series on Chicago in 1946 or the shots taken from the window of a moving train in 1950). Many of the portfolios Evans produced for the magazine are a reflection on time and its effects on the environment, the new industrial landscape. Evans himself limited the extent of his work for *Fortune* out of a concern to avoid being labelled a 'photojournalist'.

THE FARM SECURITY ADMINISTRATION

Between 1935 and 1938, Evans worked for the FSA, an organization set up by Franklin D. Roosevelt as a means of bringing aid to rural communities hit by the Depression – a role with which he was overly identified as a photographer for many years.

Evans took his orders from Roy Stryker, whom he despised. These were nevertheless productive years for him, although they involved a constant battle to safeguard his creative liberty and his autonomy. He rejected the ideological propaganda characteristic of the FSA's approach, but he also benefited from the material advantages procured by his position, in particular the opportunities for travel. Evans's itinerary took him from New Orleans in Alabama across the whole of the Deep South and provided a blueprint for the 'photographic journey' that was to inspire the likes of Robert Frank.

While fully grasping the magnitude of the social drama he was called upon to witness, Evans succeeded in maintaining a distance from his subject matter which freed his images from any conventionality or sentimentalism. The human and aesthetic experience of those few months spent in the southeastern USA from the summer of 1935 onwards was to be reflected in the whole of the rest of his work: it was an interregnum marked by a brief and intense fusion of place, personal engagement and photographic success.

KIRSTEIN AND AGEE

Certain influences accelerate an artist's career, giving his or her work the chance to mature more swiftly. It was Lincoln Kirstein, one of the great intellectual figures of the 1930s, who played this role for Evans, recognizing in his work a peculiarly American style of photography. Kirstein was the first to organize a major exhibition (in 1932) devoted to Walker Evans at New York's Museum of Modern Art. Most importantly, he wrote the accompanying text for *American Photographs*, which was to lay the foundations for a critical appraisal of the photographer's work, demonstrating his modernity and his documentary elegance free from any hint of aestheticism, and pointing up his links with Proust and Hemingway.

The friendship that grew up between Walker Evans and James Agee was something else altogether. Evans was fascinated by the

young writer from the American South, no doubt because of his successful connection with writing, but also because of his very different personality, which was as passionate as Evans's was pragmatic. He painted an unforgettable portrait of Agee, who, according to Evans, wrote 'devotedly and incessantly'.[4] The photographer would no doubt have envied the writer this utter absorption and also empathized with it, being likewise driven to strive for artistic perfection.

The names of Evans and Agee were to remain linked by the book they co-authored entitled *Let Us Now Praise Famous Men* (1941), in which literature and photography are both used to record the orchestral complexity (in Agee's words) of reality in Alabama.

LITERATURE, BAUDELAIRE AND FLAUBERT

All his life Evans regarded literature as some kind of elusive absolute. In the end he became a photographer, perhaps as a way of compensating for his initial frustration, but he is the only photographer in the history of the medium to make his art so dependent on literary models. In 1926, he enrolled at the Sorbonne, in Paris, and gravitated towards a definitive spiritual master in the novelist Gustave Flaubert. Baudelaire and Joyce completed his literary references and he was to remain faithful to these throughout his life. He said himself: 'Flaubert...by method. And Baudelaire in spirit. Yes, they certainly did influence me, in every way.'[5]

Evans's photography was not literary, however: what he was trying to do was to treat the photographic medium like a work of literature, giving it the same breadth of vision, while using purely photographic means. What he did write were the texts to accompany his *Fortune* portfolios, and the style of these works is lucid, almost dry, reminiscent of Truman Capote. Evans is said to have read French fluently and although this is not entirely clear one way or the other, it would certainly fit with what we know of him.

BOOKS

Perhaps as a result of his literary influences, Evans conceived his most important projects in the form of books. *The Bridge*, with poems

by Hart Crane (1930), *American Photographs* (1938) and *Let Us Now Praise Famous Men* (1941), on which he collaborated with James Agee, are all works produced in association with a writer as a means of exploring the link between photography and literature while respecting the specificity of each medium. Evans was certainly the first to conceive a photographic book along these lines. Imposing his own page setting, selecting the format and the cover for *American Photographs*, and placing his photographs in a single block preceding Agee's text in *Let Us Now Praise Famous Men*, he demonstrated an editorial ambition for his photography which led him to declare in 1935 that photography books were the future for the medium.[6]

From this point of view, *American Photographs* serves as something of a blueprint and must be considered as the first modern photographic book. Evans is entirely responsible for the layout and creative impact of the book. The sobriety and general economy of the page setting, the rhythmic flow of the images (following a strict sequence established by Evans himself), and the text by Lincoln Kirstein which completes the volume, all contribute to the significance of the work as a whole, amounting to a sociological portrait of America in the thirties and an accomplished aesthetic manifesto.

PORTRAITS

Not enough attention has been paid to Walker Evans's work as a portraitist. Evans developed an early dislike for the stereotypical studio portrait favoured by Steichen. The idea of the anonymous face and, more broadly, the value placed on the anonymity of the subject led him, with the image *Penny Picture Display* (1936), to question the principles of the genre by rephotographing 225 portraits in a local photographer's window at once.

Portraits are the central images of a project entitled *Subway Photographs*, for which Evans photographed (without their knowledge) a series of anonymous passengers travelling at night on the New York subway between 1938 and 1942. A large number of interiors photographed by Evans from the thirties onwards are also portraits of the people who live there, reminding us of the way that Balzac established the psychology of his characters by describing their habitual surroundings.

POSTERITY

The influence of Evans's work on contemporary American photographers is much better understood. It is to Evans that Robert Frank, for example, owes the direct, anti-aesthetic approach characteristic of those first photographs taken between 1928 and 1931, while Lee Friedlander adopted Evans's cluttered vision of the urban American landscape. Lewis Baltz and the new landscape photographers have been diligent exponents of the almost surgical scrutiny that Evans devoted to industrial waste, and the photograph of 'Richard Perkins Contractor' (1936) provided the prototype for American images of the seventies and eighties.

While he aided Robert Frank and Diane Arbus at the start of their careers, Evans was a discreet mentor, refusing to pontificate about his art. He founded no school, loathed the atmosphere of reverence surrounding the whole photographic process and kept well away from galleries. For all these reasons, although he was respected, he was also regarded with some mistrust during his lifetime.

SIGNS

Evans was always fascinated by signs, whether these were the product of the consumer society (posters, billboards, magazine covers) or a spontaneous manifestation of creativity (graffiti, etc). In each case, Evans understood how an image, once it is picked up by society, is transformed into a sign, and he himself became obsessed with recording advertising stereotypes, re-photographing images of images and collecting postcards and posters, which he would photograph, then pull down and keep. At the end of his life, Evans exhibited this collection of objects and signs alongside his own photographic work.

Evans's exploration of signs and icons, and the way they come into being, put him well ahead of his time. His photographs were themselves a more complex set of signs and, like the objects/signs that inspired them, also in danger of disappearing – or being assimilated into an ideology. When he was negotiating the terms of his employment by the FSA, Evans wrote to Roy Stryker in 1935: 'This is pure record not propaganda. The value and, if you like, even the propaganda value for the government lies in the record itself which

in the long run will prove an intelligent and farsighted thing to have done.'[7]

The photograph as sign is fundamental to an understanding of Evans's entire oeuvre.

SYMMETRY, FACADES, SURFACES, FRONTALITY

Evans's acceptance of an aesthetic order drawn from the most trivial or haphazard environment was thoroughly modern and set him apart from photographers like Ansel Adams and Edward Weston. Rather than arranging the composition, the photographer's job, as he saw it, was to centre the existing configuration of visual surfaces offering themselves up to the eye – something that was already composed and had its own order. Hence his choice of frontality when using the large format, and his refusal to eliminate foreground details that interfered with his subject. Evans captures not only the centred image but everything that relates to the object photographed, in other words its context, consciously accepting the value of that visual disorder peculiar to the American environment – one of the first photographers to do so.

Through the frontality of the image we are better able to grasp its manner of articulation and to read it fully. In Evans's work we often find the initial disorder counterbalanced by a valuing of the internal coherence of the image and a tendency to symmetry. The objective forms represented by the surfaces and innumerable facades photographed by Evans throughout his life are as much a reflection on the inability of the photographic vision to go beyond the visible world as – through the emphasis on symmetry – a quest for universal order and for a natural bias towards equilibrium.

VERNACULAR

The word 'vernacular' refers to forms of popular art, many of them spontaneous, specific to a given culture. Walker Evans and the painter Edward Hopper were two of the artists most attentive to the cultural environment of their native America, something Evans (influenced by Lincoln Kirstein) sought to represent throughout his work. From colonial architecture to objects of everyday farming life

in Alabama, via the world of poster advertising, Evans's work is a photographic record of a country hesitating on the brink of the new industrial age. This imagery of consumer objects heralds the pop art of the sixties, but what is significant here is Evans's focus on the trivial and the workaday and his eschewal of the kind of symbolism we find in the work of Stieglitz and Weston, his commitment to a descriptive literalness. American daily life was ideal subject matter for such an approach: utilitarian and devoid of specific metaphorical significance. In accepting it, Evans gave an unadorned account of the society into which he was absorbed and simultaneously affirmed his aesthetic goal, which was to provide an analysis of the primary value of things, such as writers like Hemingway and Dashiell Hammett were conducting in the field of literature.

THE URBAN ENVIRONMENT

Walker Evans had no interest whatsoever in photographing the countryside and thoroughly disliked Ansel Adams and the whole tradition of American landscape photographers. 'I draw something from being in nature, but I don't use it', he said. 'It bores...I'm interested in the hand of man and civilization.'[8]

Evans's commitment to the urban environment is evident from his first photographs, taken with a Leica in New York in 1928, and the modernist theme of city life – which Evans had found in Baudelaire, a writer he admired enormously – is a current that runs throughout his work. The majority of Evans's photographic projects are an exploration of the urban fabric. He photographed New York (1928–31), Havana (1933), New Orleans (1935), Chicago, Detroit and the cities of the eastern US, and in 1935 he wrote: 'American city is what I'm after. So might use several, keeping things typical.'[9]

The remarkable piece of photographic reportage which Evans produced in Havana to illustrate Carleton Beals's *Crime of Cuba* (1933) demonstrates the influence of Atget and his tendency to approach the street from the point of view of a passer-by. Using the small and medium format in tandem with the 8 x 10, Evans describes both the social spectacle and the vitality of the big cities with their reservoir of signs (which sometimes have a heavy sexual slant, as in the posters from Bridgeport, Connecticut, 1941).

Gilles Mora

NOTES

1 In *Walker Evans at Work*, Harper & Row, New York, 1982, p. 238.

2 As reported by John Szarkowski in his introduction to the MoMA catalogue *Walker Evans*, New York, 1971.

3 In Jeffrey W. Limerick, *An Interview with W. Evans*, 20 May 1973 (unpublished).

4 In James Agee and Walker Evans, *Let Us Now Praise Famous Men* (with a postscript by Evans), Houghton Mifflin, Boston, 1941.

5 Leslie Katz, 'Interview with W. Evans', in *Camera Viewed*, Dutton, New York, 1979, vol. 1, pp. 120–32.

6 In *Walker Evans at Work*, op. cit., p. 98.

7 Ibid., p. 112.

8 In Jeffrey W. Limerick, *An Interview with W. Evans*, op. cit.

9 In *Walker Evans at Work*, op. cit., p. 98.

1. New York, 1928–29.

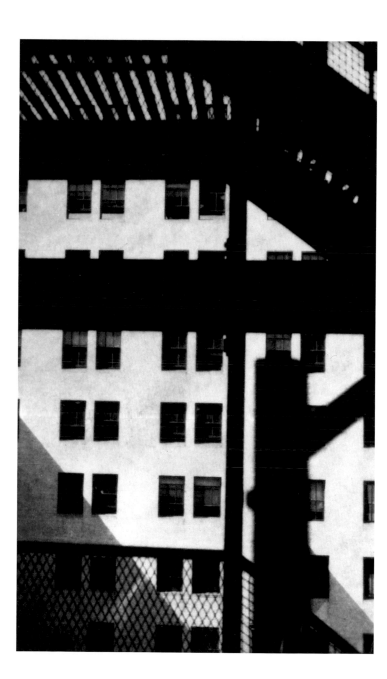

2. Brooklyn Bridge, New York, 1929.

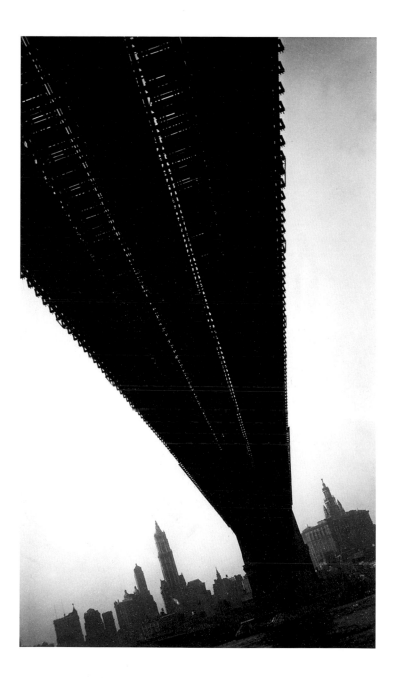

3. From the Brooklyn Bridge, New York, 1929.

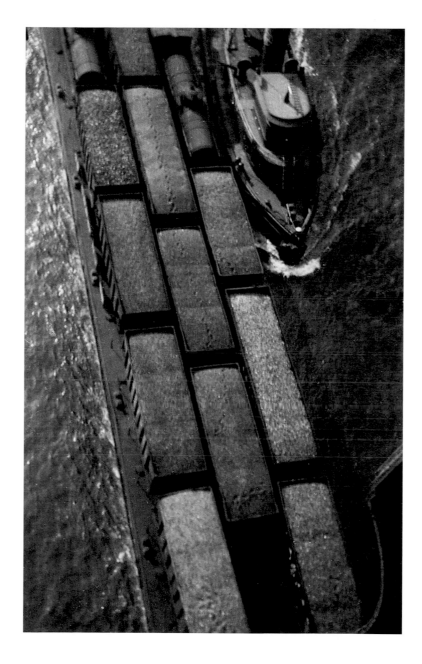

4. New York, 1929–30.

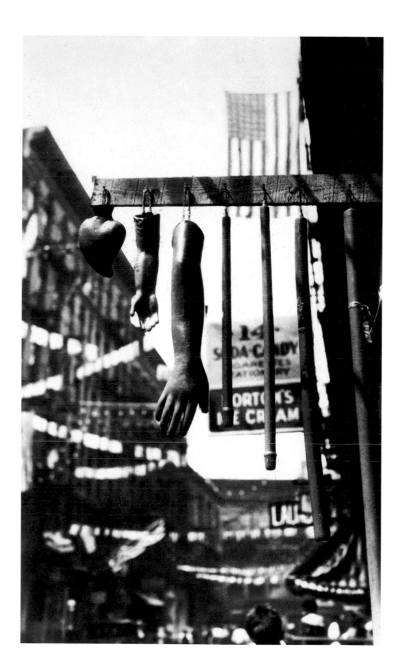

5. New York, 1928–29.

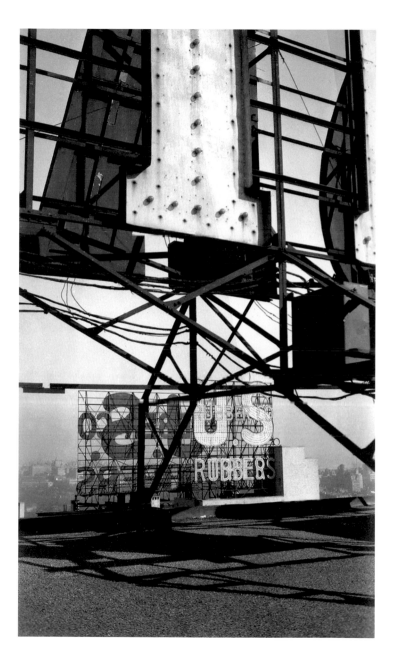

6. Girl in Fulton Street, New York, 1929.

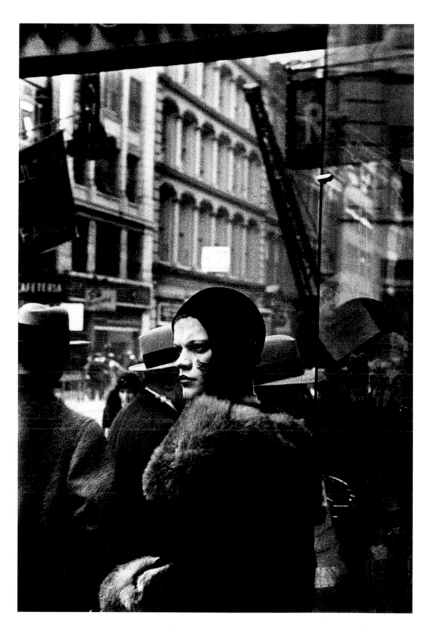

7. 42nd Street, New York, 1929.

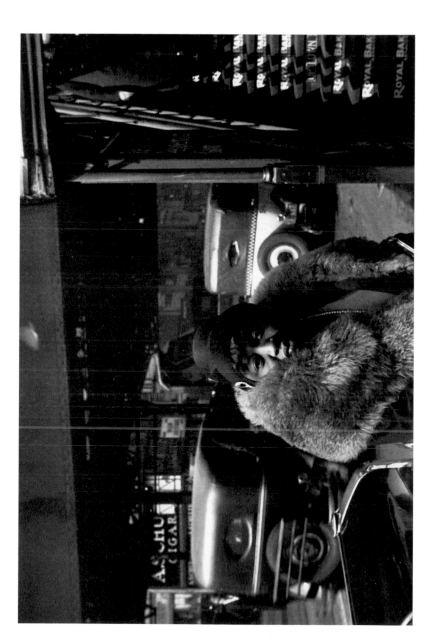

8. Couple at Coney Island, 1928.

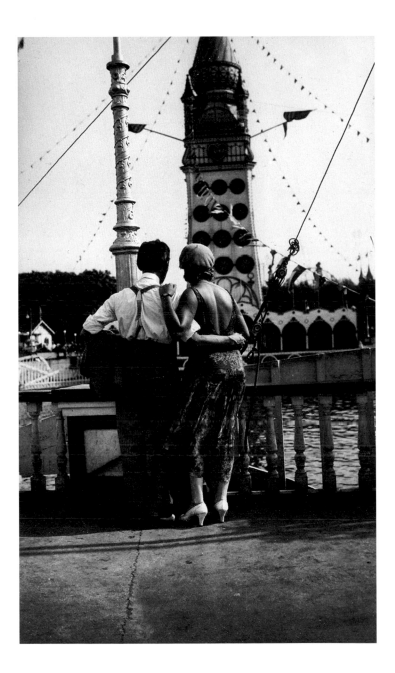

9. Window, Wellfleet, Massachusetts, 1929–31.

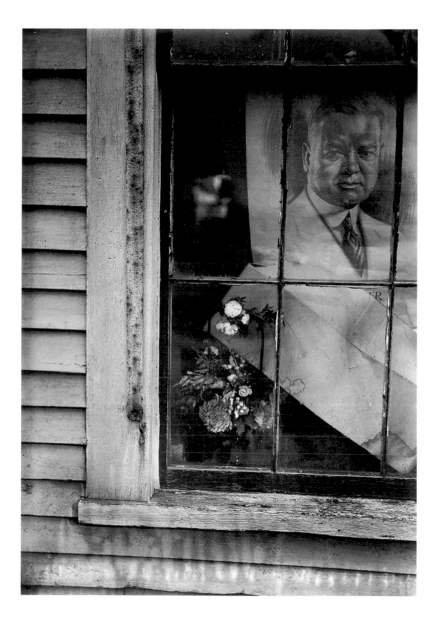

10. Torn movie poster, 1930.

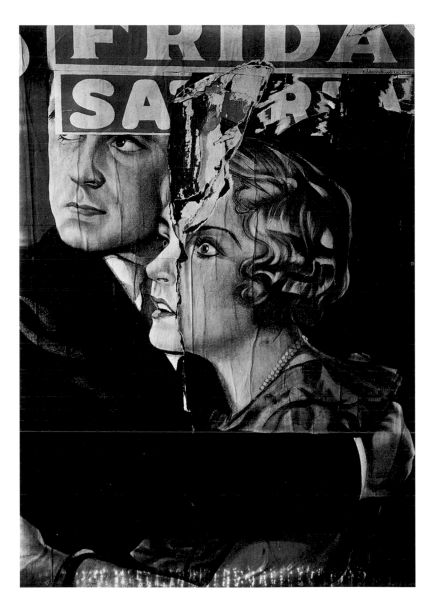

11. Posed portraits, New York, 1931.

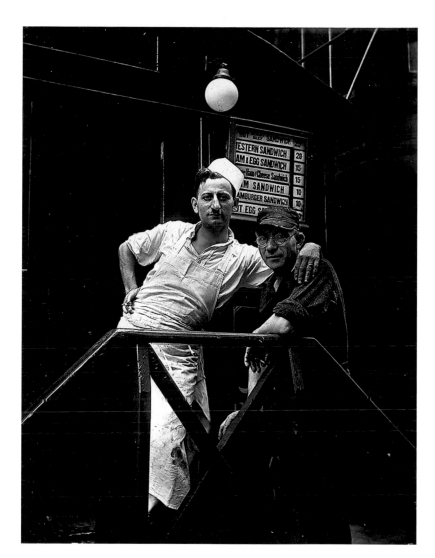

12. Main Street, Saratoga Springs, New York, 1931.

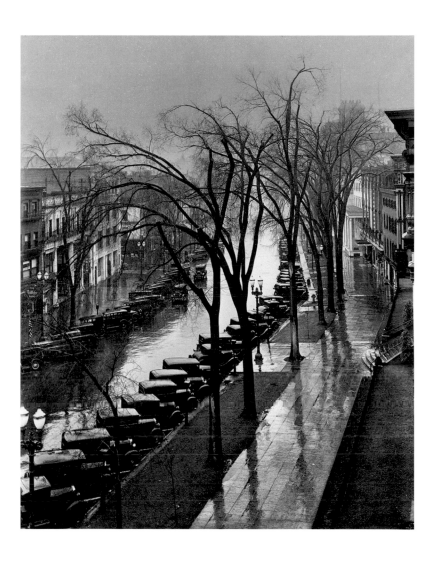

13. New York, c. 1931.

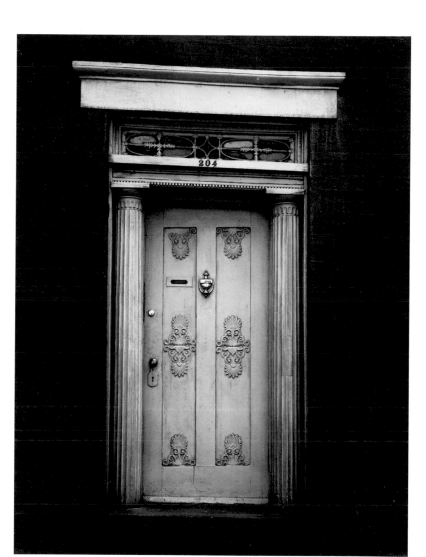

14. Stamped tin relic, 1929.

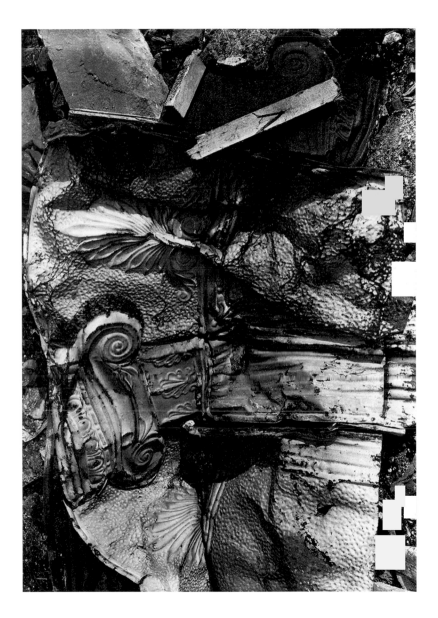

15. Roadside gas sign, 1929.

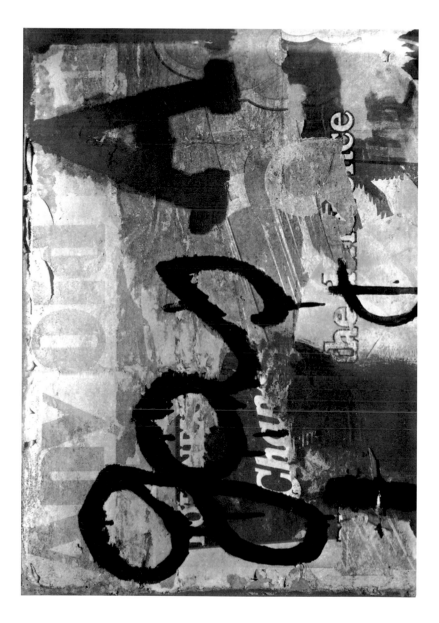

16. Parked car, small town, Main Street, 1932.

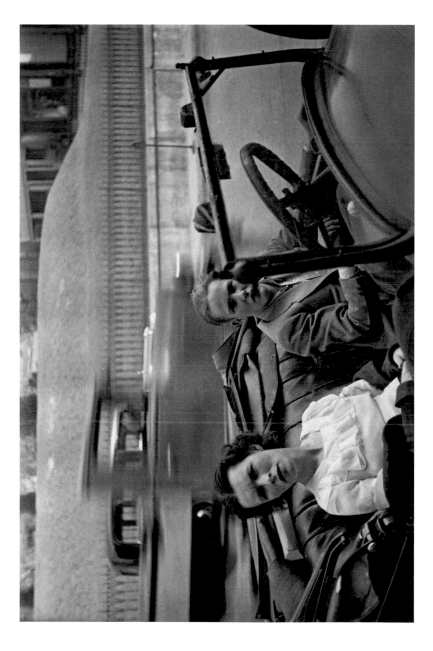

17. Westchester, New York, farm house, 1931.

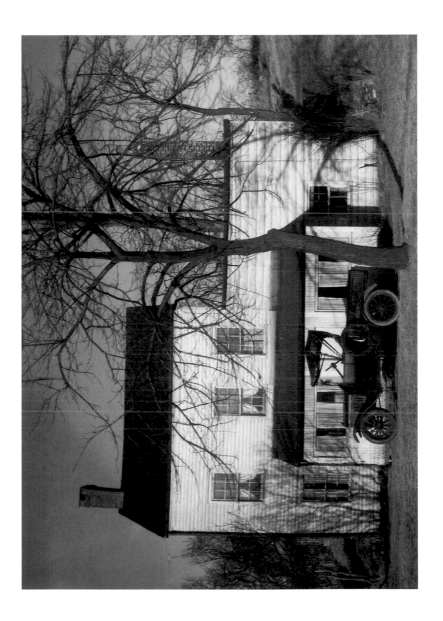

18. Joe's Auto Graveyard, Pennsylvania, 1936.

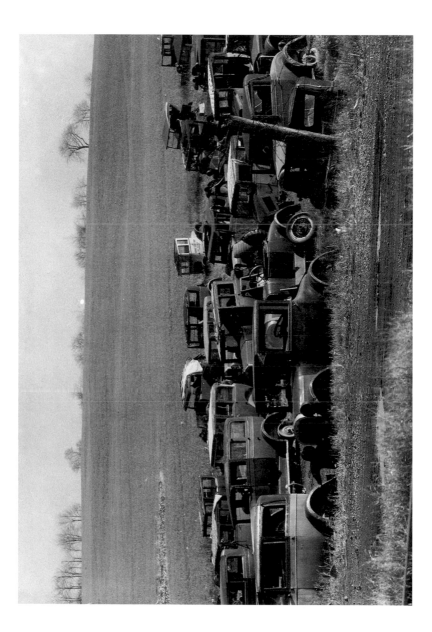

19. Cuba, 1933.

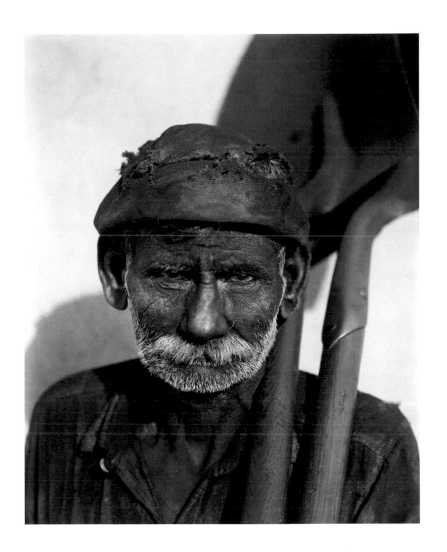

20. Havana, Cuba, 1933.

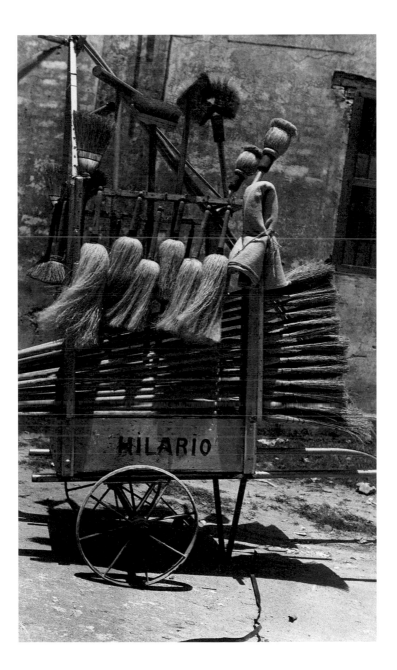

21. Citizen in downtown Havana, Cuba, 1933.

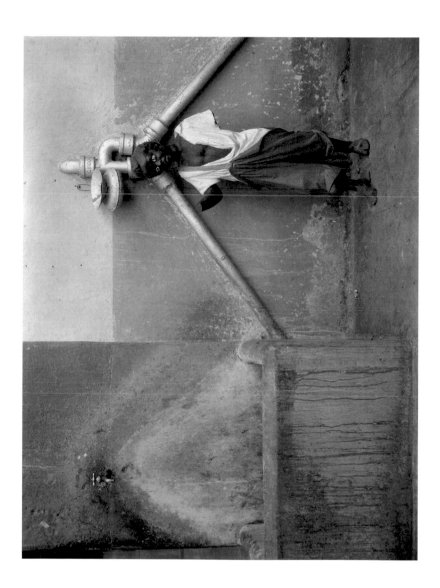

22. Havana, Cuba, 1933.

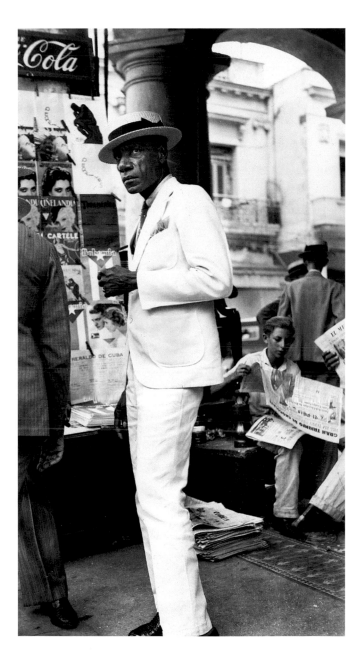

23. Lunchroom window on the Bowery, New York, 1933–34.

PEOPLES
8

RESTAURANT
DINNER

Soup Clam Chowder 5¢

Hamburger Roast 10¢
Tea or Coffee
Meat Balls Tea or Coffee
Fried Liver (Onions)
Beef Steak Pie 15¢
Breaded Veal Chops
Boiled Bacon Cabbage
Pot Roast Beans
Pigs Knuckles Crab Tea or
Spare Ribs Roast Coffee
Baked Sausages
Mackerel Dinner

Frankfurters Beans 10¢
Tea or Coffee

COLD Salads 15¢
2 Eggs any Style 10¢
Hash and Onions
Liver and Onions
Veal Cutlet
Pork Tenderloin 15¢
Fried Ham
Fried Bacon
Liver and Bacon
Pork Sausages
Hamburger Steak Onions Coffee
3 Eggs any Style
Ham and Tea or 20¢
Bacon 3 Eggs Coffee
Small Steak
Bologna Veal Sausage 25¢
3 Pork Chops

BEEF STEW 15¢
Tea or Coffee

Roast Loin of Pork
Roast Fresh Ham
Boiled Beef Tea and 20¢
Yankee Pot Roast Coffee
Broiled Ham Cabbage
FRIED or BAKED COD 5¢

FRIED MACKEREL 15¢
Tea or Coffee

MEAT BALLS Fried or Baked
with 10¢ with Cranberry 10¢
Coffee 15¢ Egg 10¢
Veal Cutlet Hamburger
Roast with
Coffee 10¢ Coffee 15¢ Butter 10¢

2 Rolls 5¢
Butter

Rolls 5¢

Coffee 5¢
Roll

2 Fried Eggs 10¢
Butter

Fried Eggs 10¢
Coffee

2 FRIED EGGS with Coffee
Fried Liver 10¢
Corned Beef Hash
Frankfurters
and Beans

Hamburger Steak
Liver and Bacon with
Fried Ham Coffee
Pork Sausage 15¢
Fried Bacon
Hashed Eggs
3 Fried Eggs
Veal Cutlet

Ham and 3 Eggs with
Bacon and 3 Eggs Coffee
Small Steak 20¢
3 Pork Chops
with Coffee 25¢

SPECIAL
Fried or Baked
Cod with
Coffee

Fried Mackerel
15¢

Beef Steak
with
By Coffee

24. Pool room near the docks, New York, 1933.

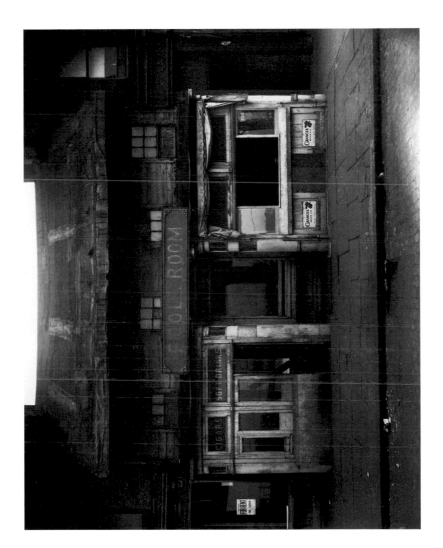

25. License photo studio, New York, 1934.

26. Billboard painters, Florida, c. 1934.

27. Sidewalk and shopfront, New Orleans, 1935.

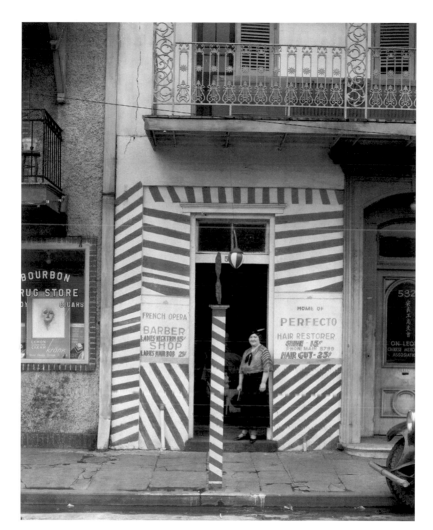

28. Main Street of Pennsylvania Town, 1936.

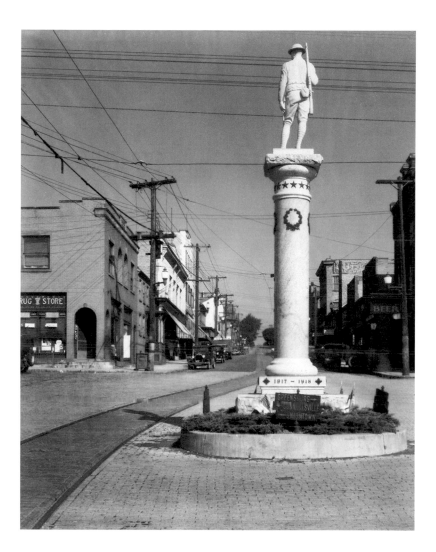

29. Main Street faces, Morgantown, West Virginia, 1936.

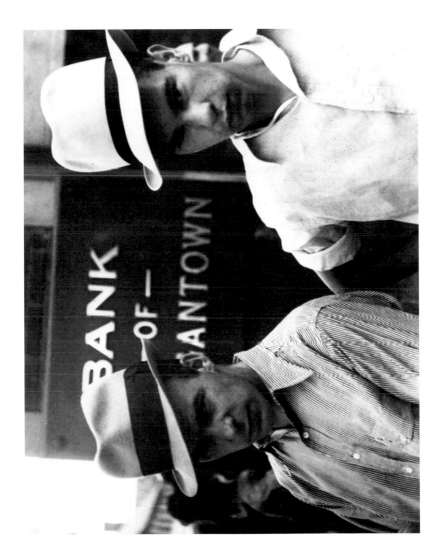

30. Garage in southern city outskirts, 1936.

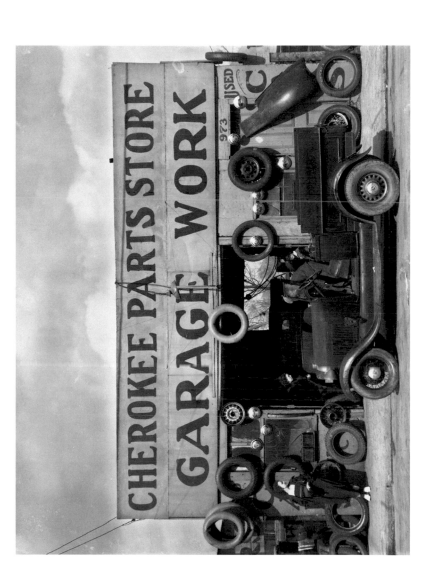

31. Negro barber shop interior, Atlanta, 1936.

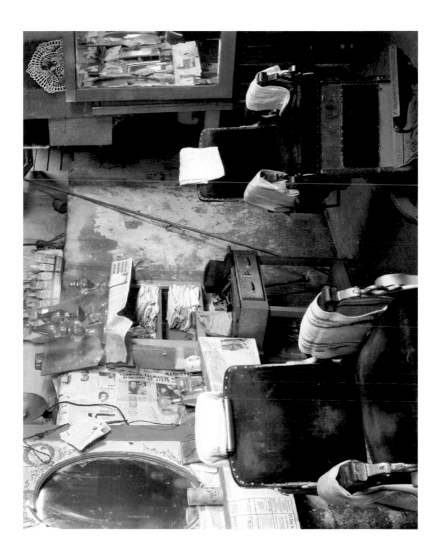

32. Houses and billboards in Atlanta, 1936.

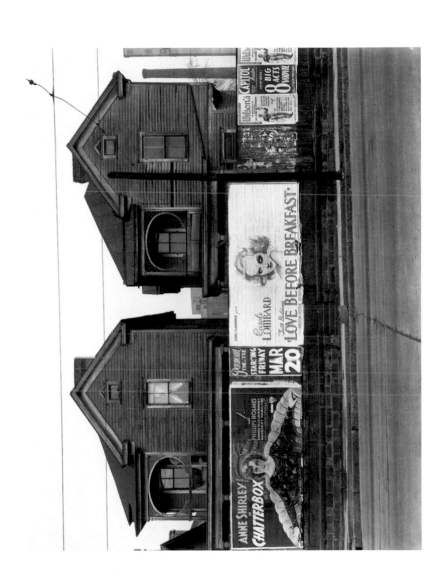

33. View of Easton, Pennsylvania, 1936.

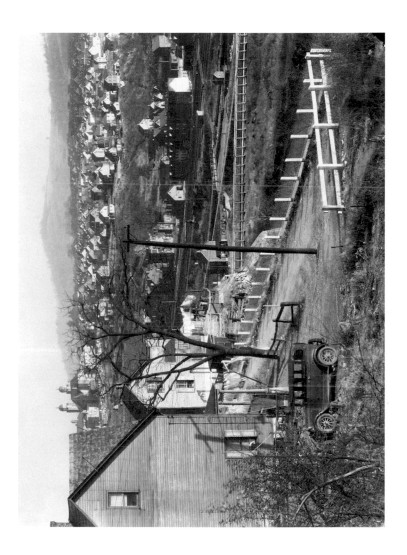

34. Gas station, Reedsville, West Virginia, 1936.

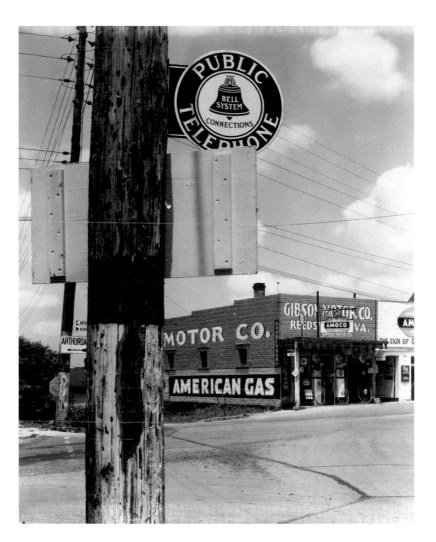

35. Graveyard and steel mill in Bethlehem, Pennsylvania, 1935.

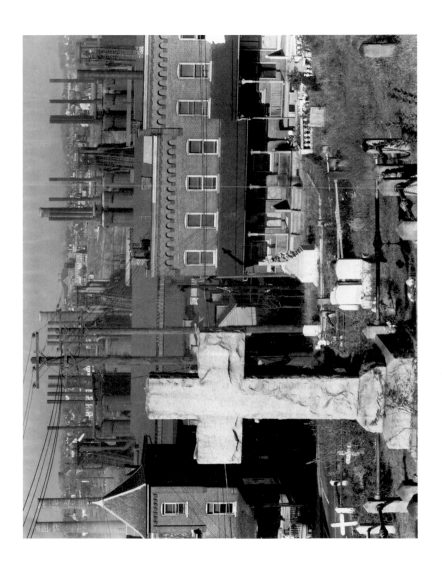

36. Mining town, West Virginia, 1936.

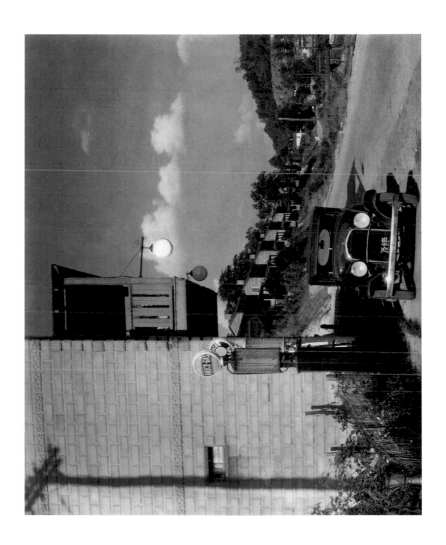

37. Corrugated tin facade, Moundville, Alabama, 1936.

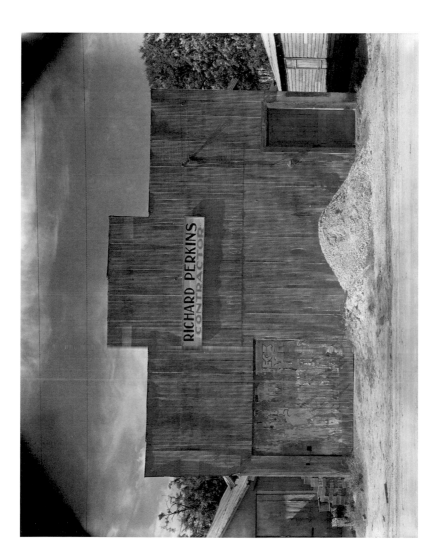

38. Furniture store sign near Birmingham, Alabama, 1936.

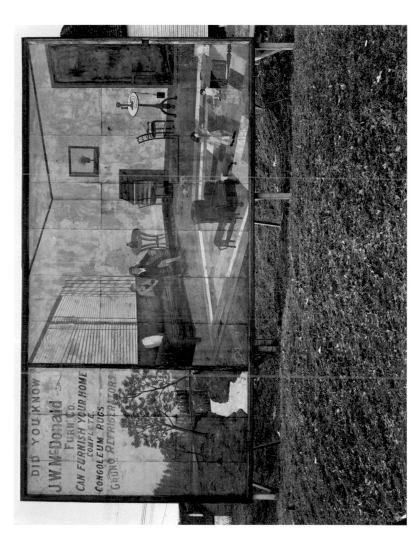

39. Mining town, Alabama, 1936.

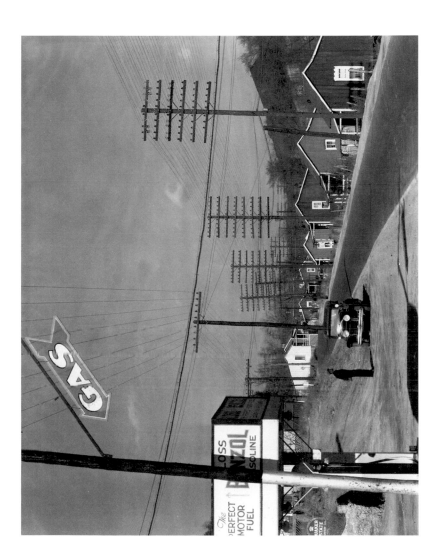

40. Hale County, Alabama, 1936.

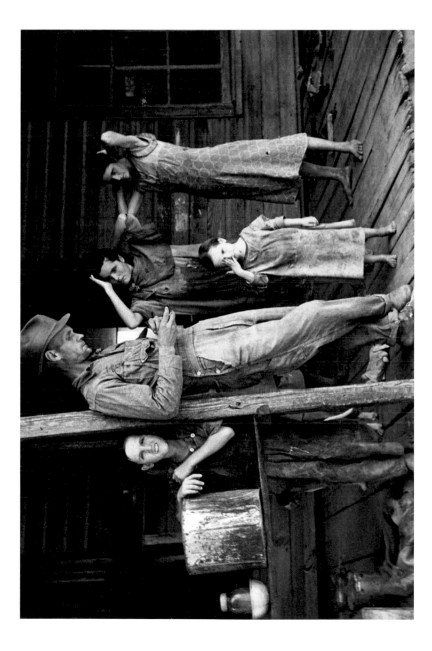

41. Alabama tenant farmer, 1936.

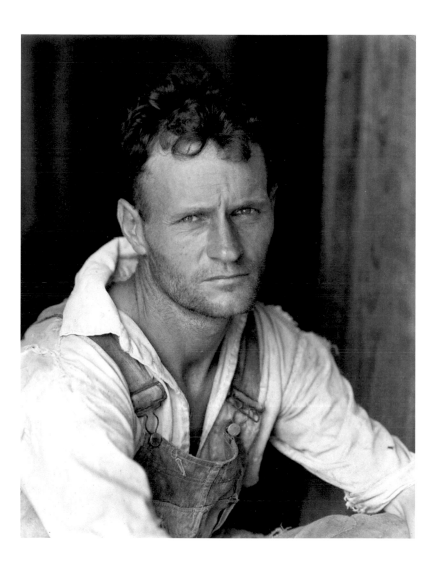

42. Alabama tenant farmer's wife, 1936.

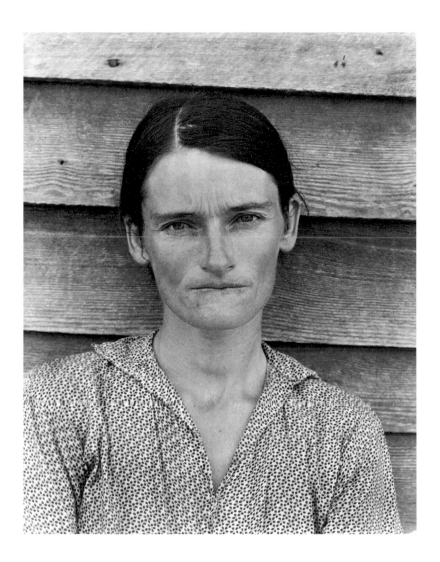

43. Alabama cotton tenant farmer family, 1936.

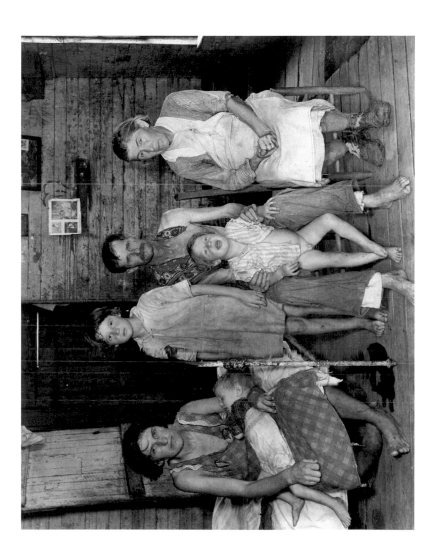

44. Hale County, Alabama, 1936.

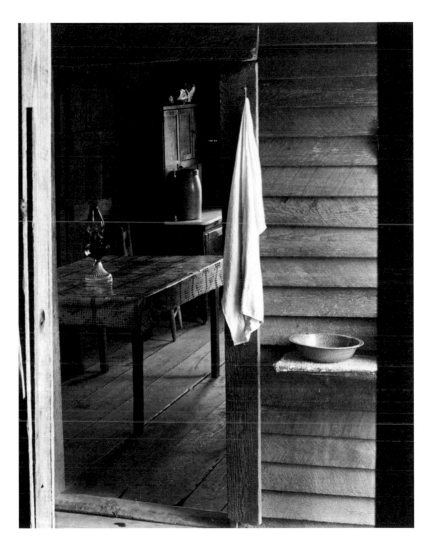

45. Wooden church, South Carolina, 1936.

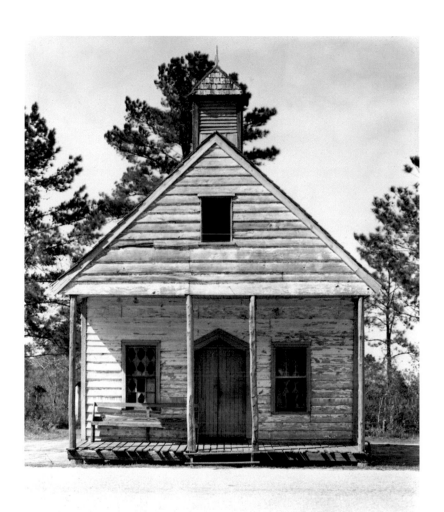

46. Church organ and pews, Alabama, 1936.

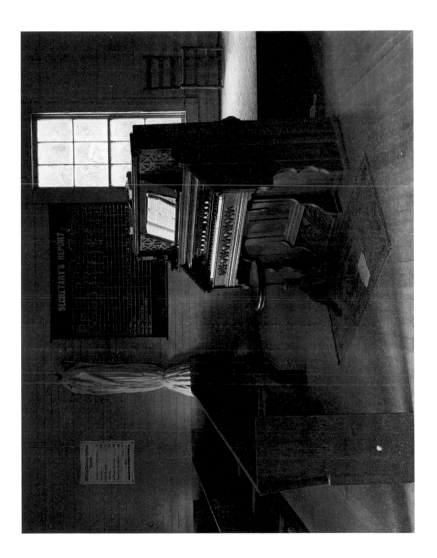

47. Child's grave, Hale County, Alabama, 1936.

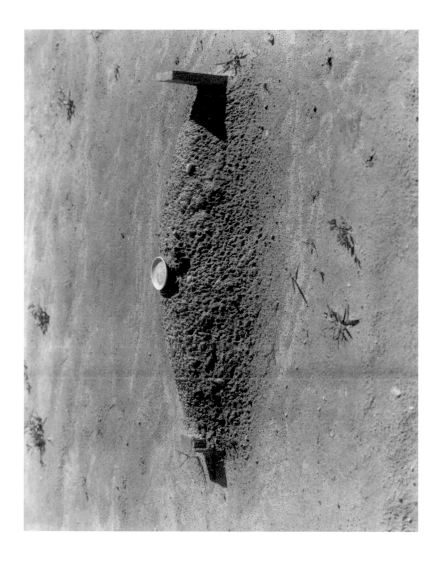

48. Post office, Sprott, Alabama, 1936.

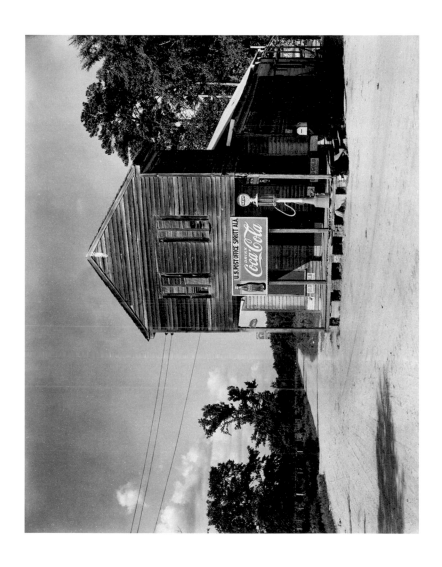

49. Greek temple building, Natchez, Mississippi, 1936.

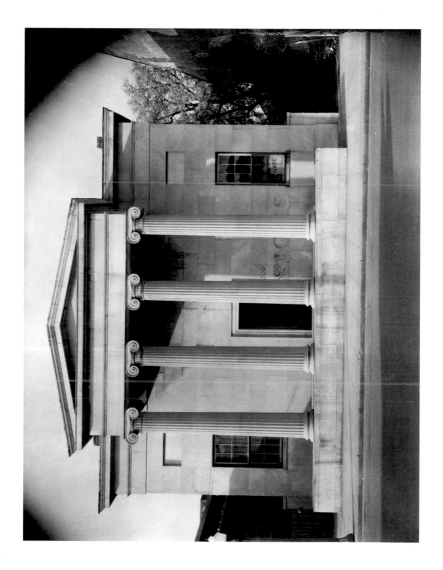

50. Roadside stand near Birmingham, Alabama, 1936.

51. Penny picture display, Savannah, Georgia, 1936.

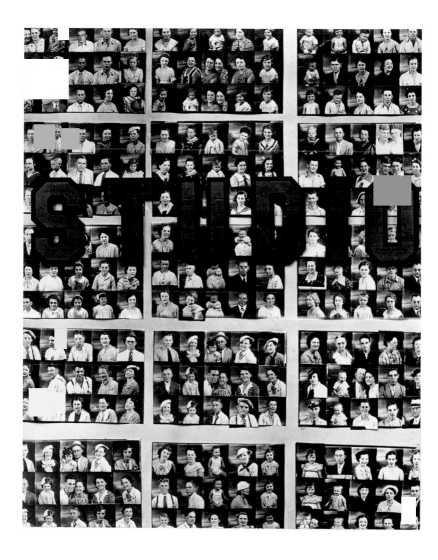

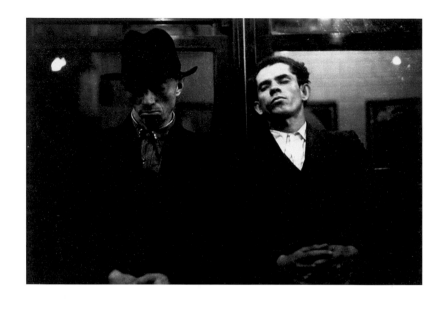

52 and 53. Subway portraits, New York, 1938–41

Overleaf:
54 and 55. Subway portraits, New York, 1938–41

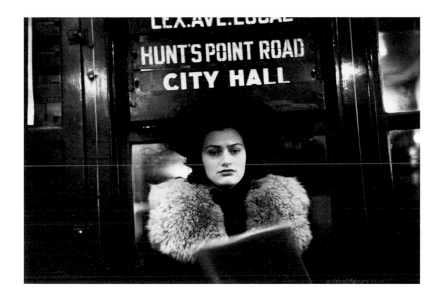

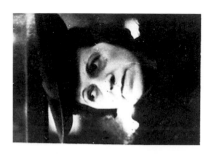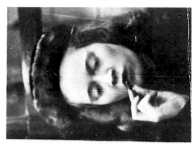

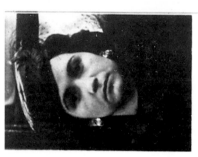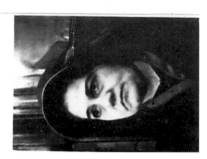

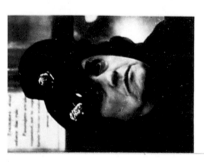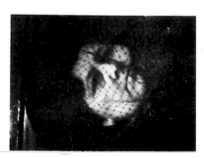

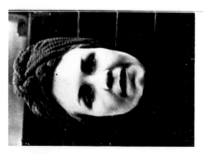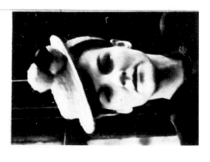

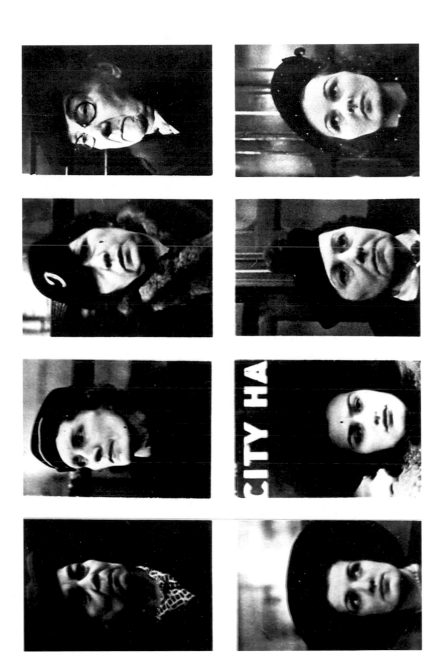

56. Resort photographer at work, Florida, 1941.

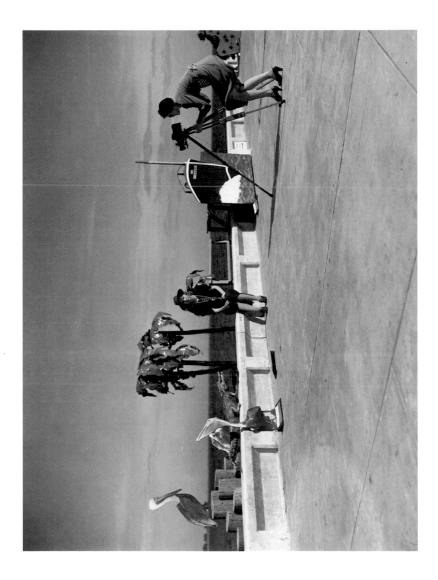

57. Shoppers, Randolph Street, Chicago, 1946.

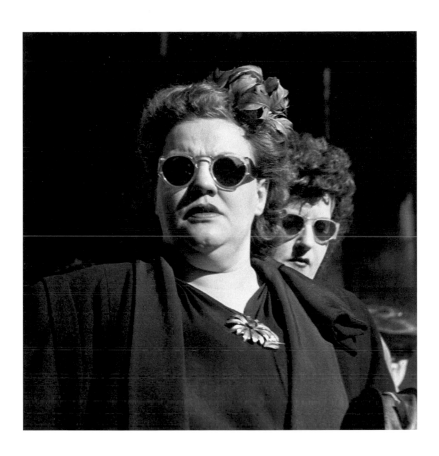

58. Graveyard, Kentucky, c. 1945.

59. Chicago, 1946.

60. Lifeboat aboard the *Liberté*, 1958.

61. Trash, c. 1968.

62. Guthrie, Kentucky, New Year's Day, 1970.

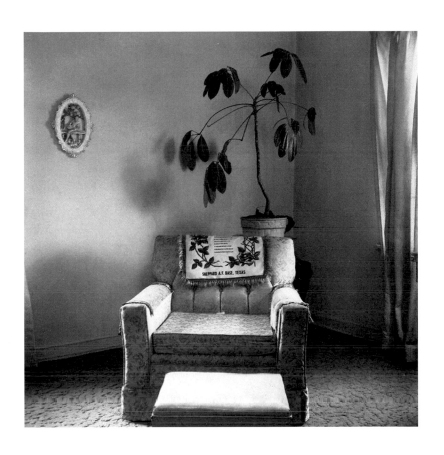

63. Robert Frank's stove, Mabu, Nova Scotia, 1971.

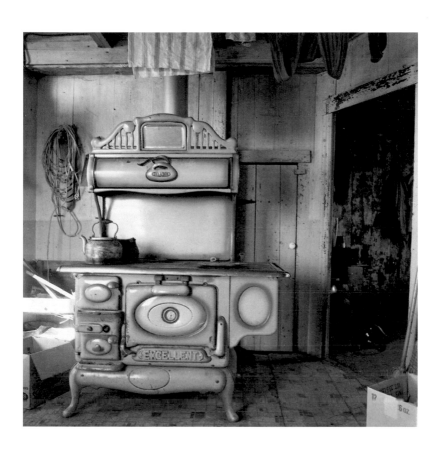

BIOGRAPHY

1903 Walker Evans is born on 3 November in St Louis, Missouri. He spends his youth in the suburbs of Chicago, then in Toledo, Ohio.

1922 Studies literature at the Phillips Academy in Andover and briefly at Williams College, Williamstown, MA.

1923 After his parents divorce, he moves to New York with his mother.

1926 Goes to Paris where he studies at the Sorbonne and tries to continue his personal writing.

1927 Returns to New York, keeps writing, and starts to become seriously interested in photography. Meets Ralph Steiner who gives him technical advice.

1929 Meets Lincoln Kirstein who becomes a mentor and adviser. Begins to photograph the Brooklyn Bridge and surroundings. Meets the poet Hart Crane, who lives in Brooklyn.

1930 Illustrates Hart Crane's book *The Bridge*. Starts to work with large-format cameras. Meets Berenice Abbott who shows him the work of Eugène Atget. His work is published in *Architectural Review*, *Creative Arts*, and *Hound & Horn*, a literary magazine founded by Lincoln Kirstein.

1931 On the advice of Kirstein, begins a series on the Victorian architecture of Boston, which goes on for several years. Exhibits with Margaret Bourke-White and Ralph Steiner at the John Becker Gallery, New York.

1933 Spends several weeks in Cuba taking pictures for Carleton Beals's book *The Crime of Cuba*. The Museum of Modern Art, New York, shows *Walker Evans: Photographs of 19th-Century Houses*.

1934 First commissions for *Fortune* magazine. Travels in Florida.

1935 Photographs the exhibition *African Negro Art* for MoMA. Hired by Roy Stryker, he starts to work for the Farm Security Administration, in the southern and central states of the US.

1936 Collaborates with James Agee on a photographic reportage project commissioned by *Fortune* magazine, on daily life in America's rural Deep South. *Fortune* eventually refuses to publish the piece.

1938 MoMA exhibits *Walker Evans: American Photographs*. The event is accompanied by a book that becomes a photography landmark. Evans begins a series of portraits taken on the New York subway while his collaboration with the FSA comes to an end.

1941 Evans and Agee publish *Let Us Now Praise Famous Men*. The work comes to be regarded as a classic collaboration between a writer and a photographer and is reprinted several times. Travels to Florida to take pictures for Karl A. Bickel's book *The Mangrove Coast*. First major reportage published in *Fortune*, 'Bridgeport's War Factories'.

1943–45 Joins *Time* magazine as a photographer and sub-editor.

1945 Becomes a photographer at *Fortune*. Three years later, he becomes picture editor, in charge of creating the magazine's visual identity.

1950 Starts photographing America's industrial landscapes.

1964 Teaches photography at Yale School of Art, New Haven, Connecticut.

1965 Ends his collaboration with *Fortune*.

1966 MoMA exhibits *Walker Evans: Subway Photographs*. These images are published in the book *Many Are Called*. Moves to Lyme, Connecticut.

1971 Major retrospective at MoMA and publication of the book *Walker Evans*, with essay by John Szarkowski.

1973 Buys his first Polaroid SX-70 and begins a new series of photographs.

1974 Continues to work with colour Polaroids. His health deteriorates.

1975 Walker Evans dies on 10 April in New Haven. His final lecture at Radcliffe College in Boston was two days earlier.

1994 The Metropolitan Museum of Art in New York acquires Walker Evans's archives.

BIBLIOGRAPHY

compiled by Philippe Séclier

Books about Walker Evans

Walker Evans, text by John Szarkowski, New York: Museum of Modern Art, 1971; reprinted 1974

Walker Evans: Photographs for the Farm Security Administration, 1935–1938, introduction by Jerold C. Maddox, New York: Da Capo Press, 1973

Images of the South: A Visit with Walker Evans and Eudora Welty, Memphis: Center for Southern Folklore, 1977

Walker Evans at Fortune 1945–1965, text by Lesley K. Baier, Wellesley, MA: Wellesley College Museum, 1978

Walker Evans: First and Last, New York: The Estate of Walker Evans, Harper & Row, 1978

Walker Evans, text by Lloyd Fonvielle, New York: Aperture, 1979; reprinted 1994 and 1997

Walker Evans and Robert Frank: An Essay on Influence, text by Tod Papageorge. New Haven, CT: Yale University Art Gallery, 1981

Walker Evans at Work, text by Jerry L. Thompson, New York: The Estate of

Walker Evans, Harper & Row, 1982; London: Thames & Hudson, 1983

Walker Evans 1903–1974, texts by Jeff Rosenheim, Vicent Todolí and Alan Trachtenberg, Valencia: Conselleria de Cultura, Educació i Ciencia de la Generalitat Valenciana, 1983

Havana 1933, text by Gilles Mora, Paris: Contrejour; New York: Pantheon Books, 1989

Walker Evans, text by Gilles Mora, Paris: Belfond/Paris Audiovisuel, 1989

Walker Evans. L'Amérique, photos des années de la Dépression, text by Michael Brix, Munich/Paris: Schirmer/Mosel, 1990

Of Time and Place: Walker Evans and William Christenberry, text by Thomas Southhall, Fort Worth, TX: Amon Carter Museum, 1990

Walker Evans, 'Photo Poche' collection, Paris: CNP, 1990

Walker Evans and Jane Ninas in New Orleans 1935–1936, text by Jeff Rosenheim, New Orleans: Historic New Orleans Collection, 1991

Walker Evans: Subway Photographs and

Other Recent Acquisitions, text by Sarah Greenough, Washington DC: National Gallery of Art, 1991

Walker Evans: The Hungry Eye, text by Gilles Mora and John T. Hill, New York: Harry N. Abrams, 1993

Walker Evans: A Biography, text by Belinda Rathbone, New York: Houghton Mifflin; London: Thames & Hudson, 1995

Walker Evans: The Getty Museum Collection, text by Judith Keller, London: Thames & Hudson, 1995

Walker Evans: Incognito, text by Leslie George Katz, New York: Eakins Press Foundation, 1995

The Last Years of Walker Evans, text by Jerry L. Thompson, London and New York: Thames & Hudson, 1997

Walker Evans: Signs, text by Andrei Codrescu, London: Thames & Hudson, 1998.

Walker Evans, biography by James R. Mellow, New York: Basic Books, 1999

Walker Evans & Company, text by Peter Galassi, New York: Museum of Modern Art, 2000

Unclassified: A Walker Evans Anthology, introduction by Maria Morris Hambourg, text by Jeff L. Rosenheim and Douglas Eklund, New York: Scalo / Metropolitan Museum of Art, 2000

Florida, text by Robert Plunket, Los Angeles. J. Paul Getty Museum, 2000

Perfect Documents: Walker Evans and African Art, 1935, text by Virginia Lee Webb, New York: Metropolitan Museum of Art, 2000

Walker Evans, text by Luc Sante, London: Phaidon, 2001

A Consciousness of Technique in 'Let Us Now Praise Famous Men', text by Victor A. Kramer, Albany, NJ: Whitston Publishing Company, 2001

Walker Evans: Cuba, text by Judith Keller and Andrei Codrescu, Los Angeles: J. Paul Getty Museum, 2001

Walker Evans: Polaroids, text by Jeff L. Rosenheim, New York: Scalo/ Metropolitan Museum of Art, 2002

Mexico–New York: Walker Evans, Henri Cartier-Bresson and Manuel Alvarez Bravo, Mexico City: Editorial RM, 2003

Lyric Documentary: Selections from Evans' Work for the US Resettlement Administration and the Farm Security Administration, 1935–1937, text by John T. Hill and Alan Trachtenberg, Göttingen: Steidl, 2006

Books by Walker Evans or in collaboration with him

The Bridge, Hart Crane with 3 photos by Walker Evans, Paris: Black Sun Press; New York: Liveright, 1930

The Crime of Cuba, Carleton Beals with 31 photos by Walker Evans, Philadelphia and London: J. B. Lippincott, 1933

African Negro Art, 477 photos from the exhibition of the same title, New York: Museum of Modern Art, 1935

American Photographs, text by Lincoln Kirstein, 87 photos, New York: Museum of Modern Art, 1938; reprinted 1962 (preface by Monroe Wheeler) and 1988

Let Us Now Praise Famous Men: Three Tenant Families, text by James Agee, Boston: Houghton Mifflin, 1941; reprinted Boston: Houghton Mifflin, 1960, 1969, 1988, 2001, and New York: Penguin, 2006

Wheaton College Photographs, preface by J. Edgar Park, 24 photos, Wheaton, MA: Wheaton College, 1941

The Mangrove Coast, Karl Bickel with 32 photos by Walker Evans, New York: Coward-McCann,1942

African Folktales and Sculpture. Paul Radin and James Johnson Sweeney, with

113 photos by Walker Evans, New York: Pantheon Books, 1952; reprinted Princeton, NJ: Princeton University Press, 1970

Many Are Called, text by James Agee, 89 photos, Boston: Houghton Mifflin, 1966; reprinted with a preface by Luc Sante and afterword by Jeff L. Rosenheim, New Haven, CT: Yale University Press, 2004

Message from the Interior, text by John Szarkowski, New York: Eakins Press, 1966

'Photography', in *Quality: Its Image in the Arts*, edited by Louis Kronenberger, essay on photography with photos selected by Walker Evans, New York: Balance House, 1969, pp. 169–211

SELECTED EXHIBITIONS

Solo exhibitions

1933 *Walker Evans: Photographs of 19th-Century Houses*, Museum of Modern Art, New York.

1938 *Walker Evans: American Photographs*, Museum of Modern Art, New York.

1948 *Walker Evans Retrospective*, Art Institute of Chicago, Chicago.

1962 *Walker Evans: American Photographs*, Museum of Modern Art, New York (touring exhibition).

1964 *Walker Evans*, Art Institute of Chicago, Chicago.

1966 *Walker Evans: Subway Photographs*, Museum of Modern Art, New York. *Walker Evans*, Robert Schoelkopf Gallery, New York.

1970 *Walker Evans: Paintings and Photographs*, The Century Association, New York.

1971 Museum of Modern Art, New York.

1973 *Walker Evans*, Robert Schoelkopf Gallery, New York.

1975 *Walker Evans*, International Center of Photography, New York.

1978 *Walker Evans*, Galerie Zabriskie, Paris.

1981 *Walker Evans*, Yajima Gallery, Montreal.

1986 *Walker Evans*, Salas Pablo Ruiz Picasso, Madrid.

1987 *Leaving Things as They Are*, Art Institute of Chicago, Chicago.

1989 *Havana 1933*, FNAC, Paris.

1990 Lenbachhaus, Munich. *Walker Evans*, Galerie Municipale du Château d'Eau, Toulouse.

1991 *Walker Evans: Subway Photographs and Other Recent Acquisitions*, National Gallery of Art, Washington DC.

1998 *Walker Evans: Simple Secrets: Photographs from the Collection of Marian and Benjamin A. Hill*, High Museum of Art, Atlanta. Touring exhibition (1998–99): International Center of Photography, New York; Whitney Museum of Art at Champion, Stamford, CT; Detroit Institute of Arts, Detroit. *Walker Evans, Public Photographs, 1935–1937*, University of Buffalo Art Gallery, Buffalo.

2000 *Walker Evans*, Metropolitan Museum of Art, New York. Touring exhibition (2000–2001): San Francisco Museum of Modern Art; Museum of Fine Arts, Houston.

2003 *Walker Evans: The Collection of*

the Minneapolis Institute of Arts, Minneapolis.

2005 *Walker Evans and James Agee: Let Us Now Praise Famous Men*, University of Michigan Museum of Art, Ann Arbor, MI. *Ernest Hemingway and Walker Evans: Three Weeks in Cuba, 1933*, Boca Raton Museum of Art, Boca Raton, FL.

2006 *Walker Evans: Carbon and Silver*, Yale University School of Art, New Haven, CT. *Walker Evans: Photographs from 1935–1936*, Midlands Arts Centre, Birmingham.

Group exhibitions

1930 *International Photography, Harvard Society for Contemporary Art*, Cambridge, MA.

1931 *Photographs by Three Americans*, (Evans, Margaret Bourke-White, Ralph Steiner), John Becker Gallery, New York.

1932 *Walker Evans and George Platt Lynes*, Julien Levy Gallery, New York. *Modern Photography at Home and Abroad*, Albright Art Gallery, Buffalo, NY. *International Photographers*, Brooklyn Museum, Brooklyn, NY.

1935 *Documentary and Anti-Graphic: Photographs by Cartier-Bresson, Evans and Alvarez Bravo*, Julien Levy Gallery, New York.

1937 *Photography 1839–1937*, Museum of Modern Art, New York.

1938 *First International Photography Exposition*, Grand Central Palace, New York.

1939 *Art in Our Time*, Museum of Modern Art, New York.

1956 *Diogenes with a Camera III*, Museum of Modern Art, New York.

1962 *The Bitter Years 1935–1941*, Museum of Modern Art, New York.

1965 *Contemporary Art at Yale: 1*, Yale University Art Gallery, New Haven, CT.

1966 *The John Simon Guggenheim Memorial Foundation Fellows in Photography*, Philadelphia College of Art, Philadelphia.

1968 *Just Before the War*, Newport Harbor Art Museum, Balboa, CA.

1981 *Walker Evans and Robert Frank*, Yale University Art Gallery, New Haven, CT.

1989 *The Deep South*, Archevêché, Arles, France.

1992 *Walker Evans & Dan Graham*, Witte de With Center for Contemporary Art, Rotterdam. Touring exhibition (1992–94): Musée Cantini, Marseilles; Westfälisches Landesmuseum für Kunst und Kulturgeschichte, Münster; Whitney Museum of American Art, New York.

1995 *American Photography 1890–1965 from the Museum of Modern Art*, Museum of Modern Art, New York.

2000 *Walker Evans & Company*, Museum of Modern Art, New York. Exhibition shown in 2001 at the J. Paul Getty Museum, Malibu, CA. *Walker Evans / Sources and Influence: Selections from the Prentice and Paul Sack Photographic Trust*, Museum of Modern Art, San Francisco. *How You Look At It: Photographs of the 20th Century*, Sprengel Museum Hanover, Städelsches Kunsinstitut and Städische Galerie, Frankfurt.

2001 *The American Tradition & Walker Evans: Photographs from the Getty Collection*, J. Paul Getty Museum, Malibu, CA.

2003 *Cruel and Tender*, Tate Modern, London, and Museum Ludwig, Cologne (2004). New York: Capital of Photography, Jewish Historical Museum, New York.

2004 *Documentary and Anti-Graphic: Photographs by Cartier-Bresson, Evans and Alvarez Bravo* (reconstruction of the 1935 exhibition at the Julien Levy Gallery, New York), Fondation Henri Cartier-Bresson, Paris; Musée de l'Elysée, Lausanne (2005). *Photographers of*

Genius, J. Paul Getty Museum, Los Angeles.

2005 *La Photographie à l'épreuve*, MAM, Musée d'Art Moderne de Saint-Etienne, Saint-Etienne, France. *Dreaming of Tomorrow*, Metropolitan Museum of Photography, Tokyo.

2006 *The Streets of New York*, National Gallery of Art, Washington DC. *Bound for Glory, America in Color: 1939–1943*, FOAM Fotografienmuseum, Amsterdam.

2007 *Far from Home: Photography, Travel, and Inspiration*, Art Institute of Chicago, Chicago.